THE HOLE
BOOK

To Jupiter, Maximus, and Nikolai

GREGORY R.
MILLER & CO.

Gregory R. Miller & Co.
62 Cooper Square
New York, NY 10003
grmandco.com

Available through:
ARTBOOK | D.A.P.
75 Broad Street, Suite 630
New York, NY 10004
artbook.com

Designed by Kathryn Davies
Project management and editing by Alli Brydon

ISBN 978-1-941366-49-3

Library of Congress Control Number: 2022942217

I was born an explorer.

I know this because my first questions were
who is this?
and
what is that?

I stuck my fingers everywhere.

I risked my life with electrical outlets,
eyeholes of scissors,
and the mouth of somebody's dog.

Holes attracted me the most.

Some
were
dark
and
hid
things.

Others were open and let me
see what was behind them.

Some holes I dug myself.

I poked my finger into slices of bread,
sheets of paper,
and the sand of beaches
all over the world.

As a child, I liked my toys.

They were always there,
and I could share secrets with them.

 But holes were different.

They, too, were there,
but they *were* the secret.

So, when I grew up,
I became an explorer of holes.

I visited caves, grottos, mineshafts,
springs, and cavities.

Some I tried to measure.

I kept records.

- pinhole
- grotto
- keyhole
- tunnel
- cheese hole
- cavern
- spring
- well
- sinkhole
- mothhole
- manhole
- wormhole
- black hole
- porthole
- button hole
- peephole

And, for many holes, I made maps.

porthole

black hole

rabbit hole

manhole

sinkhole

garbage hole

loophole

As a pastime,
I dug big holes of my own.
They were the size of my room.

Because I was afraid of the dark,
I kept a big ladder to climb out.
(And a flashlight, just in case.)

I saw many potholes
into which
coins and bottlecaps

fell.

And I saw sinkholes
full of cars,
trees, and
even houses.

Some holes were important;
others were less so.

Keyholes were out of fashion,
and peepholes were morally questionable.

And—I was told—nobody
wants a hole in the head.

keyhole peephole pinhole

I also looked for books about holes,
but holes were not popular topics among authors.
I found only one old treatise.

Clearly, I was the missing scholar on holes
and would have to write my own book.

Afcéfio Recta.	Decimæ.	Vndecimæ.	Duodecimæ	Primæ.	Secundæ.	Tertiæ.
181						
182						
183						
184						
185						
186						
187						
188						
189						
190						
191						
192						
193						
194						
195						
196						
197						
198						
199						
200						
201						
202						
203						
204						
205						
206						
207						
208						
209						
210						

So, I got to work.
There were many questions
without answers.

Does a hole dug into a mountain
 become a tunnel only
 if it leads to an exit?

And if digging stops just an inch before the exit,
does it stay a hole?

Why are doughnut holes
not holes?

They are quite the opposite:
nuts-of-dough that leave holes behind.

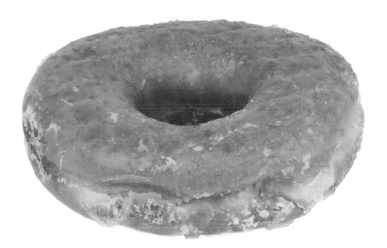

dough-hole dough-nut

And why could nobody explain
why manholes exclude women?

I discovered that a neighbor
had dug a big hole in the ground.
He made money by charging people
who wanted to dump their garbage into it.

At some point,
this hole will fill up to the top.
With no emptiness left,
will it stop being a hole?

All these questions were troubling.
They led me down a rabbit hole . . .

rabbit hole

. . . filled with lots of philosophy
but no rabbits.

philosophy hole

Sorry, a breeze
 on my big toe
 is distracting me.

I have a hole in my sock.
Very odd!

A sock has a hole for a foot,
and now my sock has another hole.

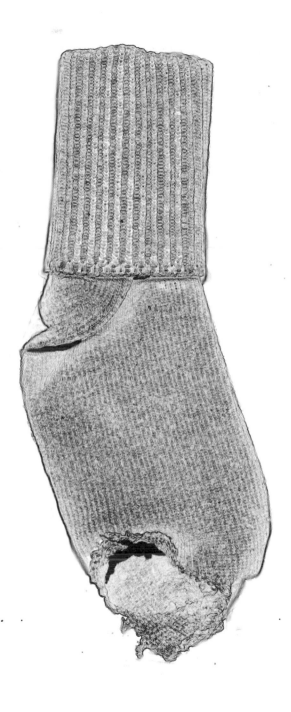

What if this sock gets more holes in it
that add up to one very big hole
that holds all the other holes?

one hole

one hole
containing
10 holes

one hole
containing
100 holes

one hole
containing
1000 holes

one hole
containing
10000 holes

one hole
containing
100000 holes

When does a sock

stop being a sock?

I have heard of black holes
that are left in the Universe
when stars die.

Planets, other stars,
and their own holes
all disappear inside them.

black hole
(closeups)

I decided to gaze at the sky
through my telescope,
looking for a black hole.

But blackness hid blackness.

And I asked myself:
even if I found a black hole,
how would I know?

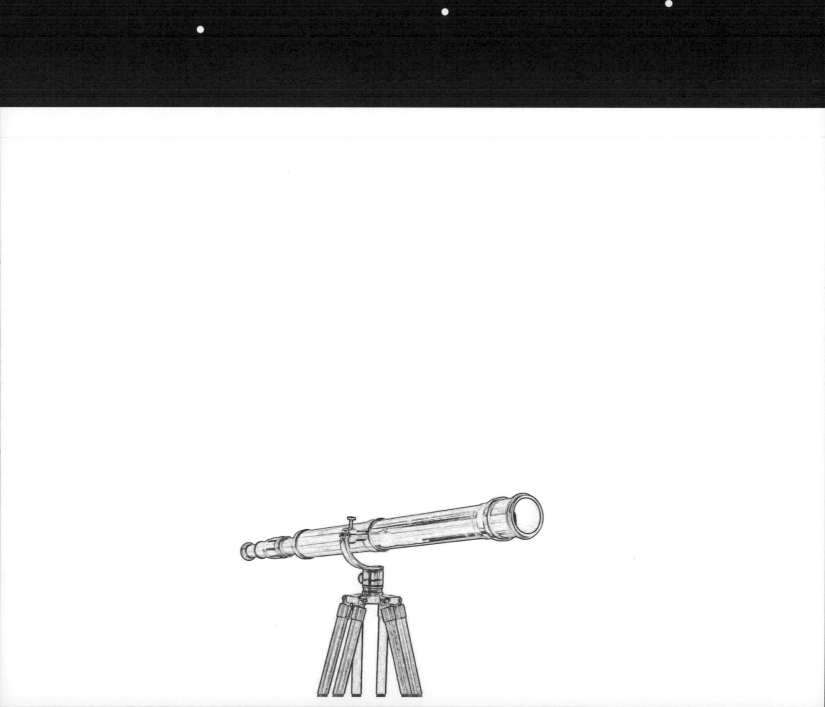

Skygazing made me hungry,
as if there were a hole in my stomach.
I went to make a sandwich.

I wanted Swiss cheese,
but we only had American.

American cheese

So, I poked some holes in a slice,
but the taste didn't change.

What, then, makes Swiss cheese Swiss?

cheese

Can nationality affect taste?

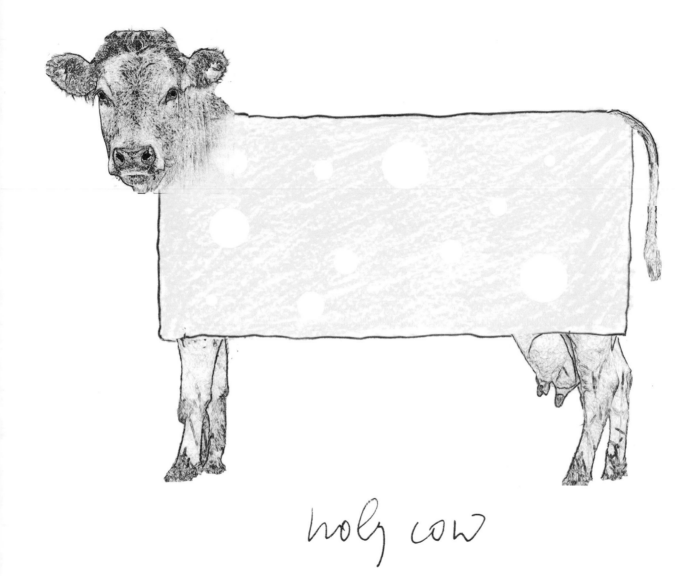

holy cow

It turns out that cheese holes
are created by farts of bacteria
named *Propionibacterium freudenreichii*.

Wait! I'd better write this down.

I took off my sock
and looked at the hole again.

I couldn't tell if it was the sock
or the hole
that had just turned inside out.

Or did the sock turn

the hole around?

And then I wondered:

can holes have color?

I went to bed not knowing anymore
if I was still exploring holes
 or only questions
 and questions on top
 of questions.

One thing was for sure:
holes are where questions are made!

a hole in the whole a whole hole

I checked if I had my ladder nearby
(and my flashlight, just in case)
and turned off the light.

I thought,

Good Night to the World

and was grateful
for the silence in my bed.

The silence was a peaceful hole in all that noise,
and it completely filled my head.
(With a hole?)

Any answers would have to wait
until tomorrow.